THE
Little Book of
ONTARIO

GEORGE FISCHER

NIMBUS
PUBLISHING LTD

Nimbus Publishing Limited
3731 Mackintosh St, Halifax, NS B3K 5A5
(902) 455-4286 nimbus.ca

Printed and bound in Canada

NB1267

Cover and interior design: Jenn Embree
Research/captions: Catharine Barker
Front cover ⁓ Clear, turquoise waters lap the shores of Cabot Head Provincial Nature Reserve. The northern portion of the reserve is within the Bruce Peninsula National Park. (Miller Lake)
Back cover ⁓ The Ferguson Gristmill operated from 1857 to 1940 on the Rocky Saugeen River. The charming building is now a private residence. (Near Durham)

Library and Archives Canada Cataloguing in Publication

Fischer, George, 1954- photographer, author
The little book of Ontario / George Fischer.
ISBN 978-1-77108-457-4 (hardcover)
1. Ontario—Pictorial works. I. Title. II. Title: Ontario.

FC3062.F57 2017 971.3'050222 C2016-908011-0

Nimbus Publishing acknowledges the financial support for its publishing activities from the Government of Canada through the Canada Book Fund (CBF) and the Canada Council for the Arts, and from the Province of Nova Scotia. We are pleased to work in partnership with the Province of Nova Scotia to develop and promote our creative industries for the benefit of all Nova Scotians.

Introduction

AS MY HOME FOR THIRTY YEARS, ONTARIO IS SUCH AN INTEGRAL part of who I am that pieces of it always come with me, no matter where in the world I travel.

My passion for this huge, diverse province pushes me to explore deeper and deeper into its treasures. I roam from Canada's southernmost point near Pelee to the Manitoba–Ontario border and Hudson Bay in the west and north, then east to the St. Lawrence River. And with 17 percent of its one million square kilometres covered by lakes, the province is aptly named "Ontario" from the Huron word for "beautiful water."

Ontario is not only Canada's most populous province, but also the country's most diverse: more than 25 percent of its residents are born outside our borders. It has also produced some of the world's most talented and celebrated artists, journalists, athletes, and scientists. So as a landscape photographer and outdoorsman, I like to think I am in good company. When I paddle the peaceful rivers of Muskoka, Haliburton, and Algonquin in my canoe, I feel a connection to the Aboriginal peoples who arrived in Ontario ten thousand years ago, navigating these same waters in their birchbark canoes.

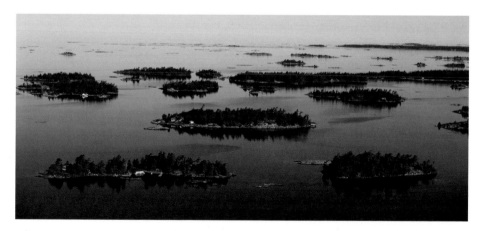

ABOVE :~ The largest group of freshwater islands in the world, Georgian Bay's 30,000 Islands were discovered by tourists in the late 1800s. While rocks often make the waters treacherous, the area offers some of the world's greatest cruising.

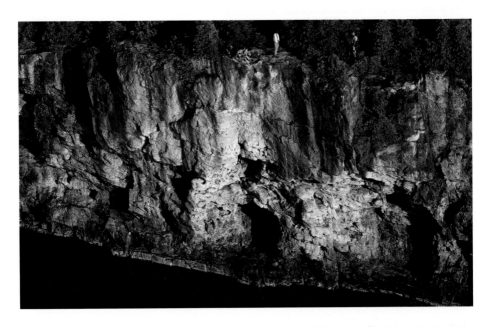

ABOVE ~ Moments with friends are never wasted time. (Georgian Bay)

I also enjoy tracing the routes of the province's first European explorers—the legendary French-Canadian "voyageurs"—who loaded up enormous canoes with beaver, lynx, and otter pelts they purchased from the Aboriginal people to sell to Europe's elite during the seventeenth and eighteenth centuries. The lucrative fur trade soon attracted English settlers to the area as well, while wars with the Americans eventually drove increasing numbers of British Loyalists northward. Modern explorers like me can canoe through provincial parks or wilderness, visit the Canadian Canoe Museum in Peterborough, and relive the fur-trading era at Fort William Historical Park. Fortunately for history buffs, the province is also dotted with pioneer villages, stone forts, historical castles, and landmarks where we can walk in the footsteps of citizens past. Among those were heroes such as Laura Secord, British allies such as Mohawk war chief Joseph Brant, and abolitionists such as Reverend Josiah Henson, immortalized in Harriet Beecher Stowe's novel, *Uncle Tom's Cabin*.

In Ontario, each of the four seasons is a gem. Summer moments for me are about sinking my toes into the rolling dunes of Sandbanks Provincial Park, enjoying the pillowy beaches at Long Point, or disturbing the peace on Georgian

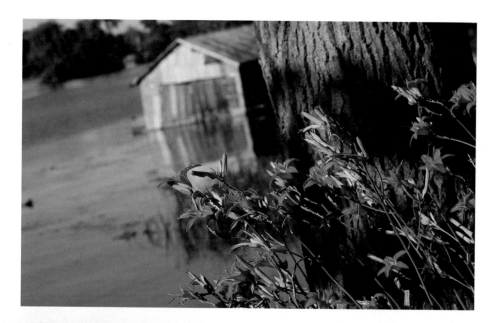

ABOVE ∾ Able to thrive in moist soil, tiger day lilies grow everywhere from hills and valleys to roadsides and ditches. Sometimes seen as an invasive species, they are nicknamed "ditch lily." (The Thousand Islands)

Bay by cannonballing off the deck into the water. They are about early-morning mists rising from the lake and haunting loon calls in Algonquin Park. In autumn, I love to crash through harvested cornfields, rustling dry stalks—and take some home to decorate the porch. In winter, the nostalgic clatter of ice skates on frozen ponds recalls my childhood. And every spring the cycle starts anew.

While my home is in Toronto, I have some favourite getaways to the near north. At my country house in Simcoe County, I plan for summer weekends with friends at the local community tennis courts so I can squeeze in a few more games. I can drive, of course, but give me a bike and some extra time and I'll opt for cycling excursions. These can go to my cottage from Toronto or around the Thousand Islands Region. And in winter, you can find my cross-country ski tracks around Orillia, Muskoka, and Haliburton.

Ontario has left an indelible imprint on my soul. This book is a journey of love and joy for one of the world's most enduring and fascinating places. I hope you will find my emotions contagious.

—*George Fischer*

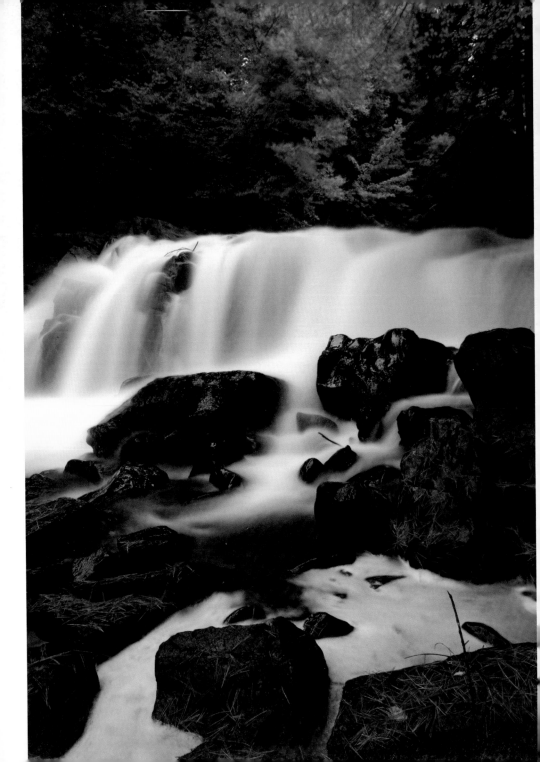

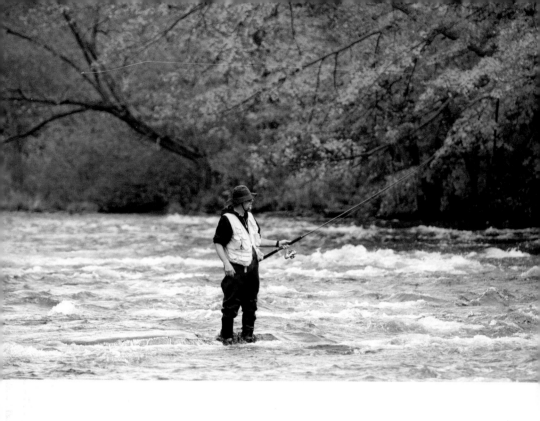

ABOVE ∾ Ontario boasts some of the world's best fishing, whether it's in cold-water rivers, wilderness streams, or an ice-fishing hut on a frozen lake. (Haliburton)

FACING ∾ Unspoiled nature shelters Brooks Falls, a surprisingly accessible cascade. (Emsdale)

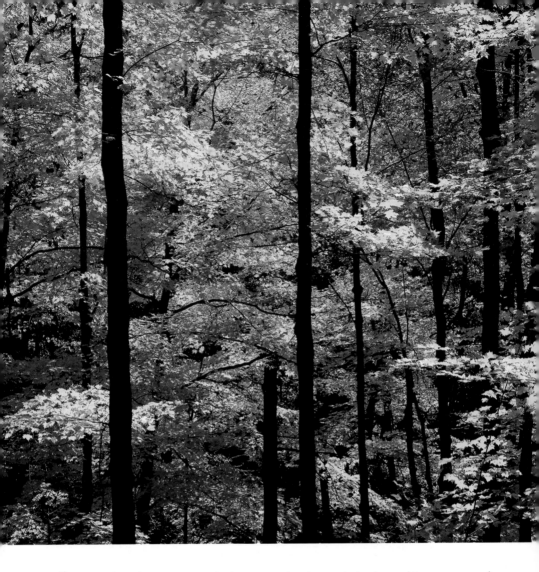

ABOVE ~ Warm hues saturate the leaves as the days get shorter and trees prepare for winter. The fall colours attract hordes of sightseers. (Algonquin Provincial Park)

FACING ~ Reflections of fall trees against a crisp blue sky paint a pond in vibrant colours. As the leaves turn from green to gold and red, they attract weekend trippers searching for spectacular displays. (Algonquin Park, Whitney)

OVERLEAF ~ A small stand of gray birches filters the sunlight. The trees were initially more prevalent in eastern Canada, but are spreading west and north.

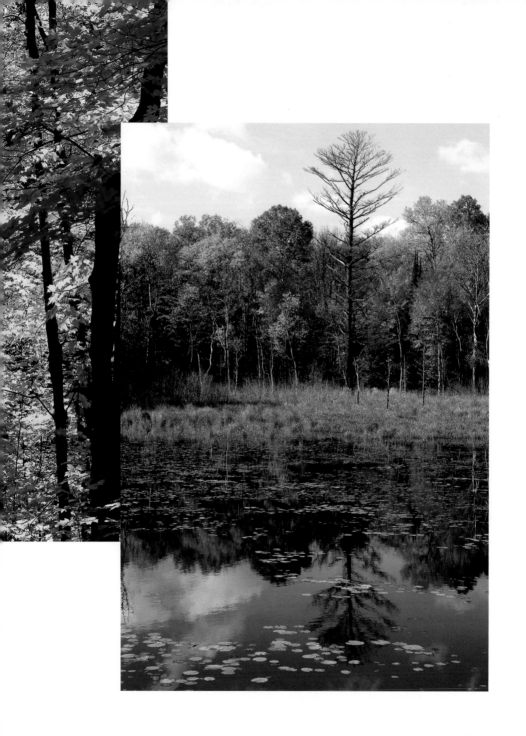

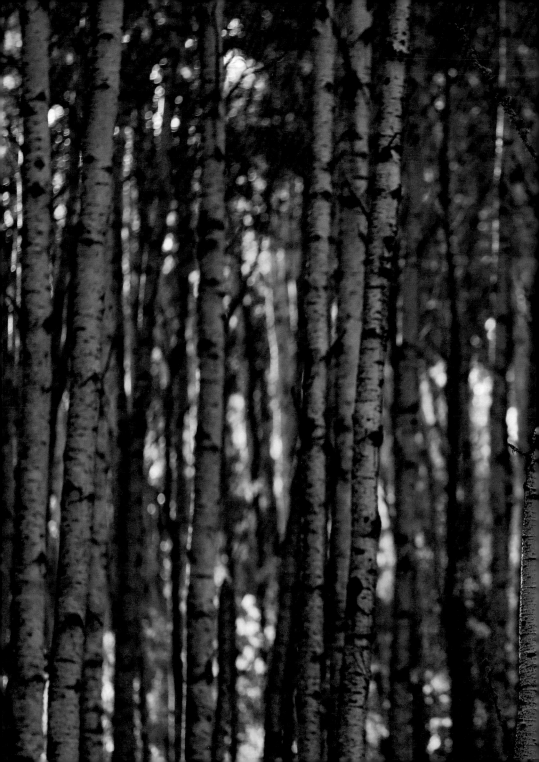

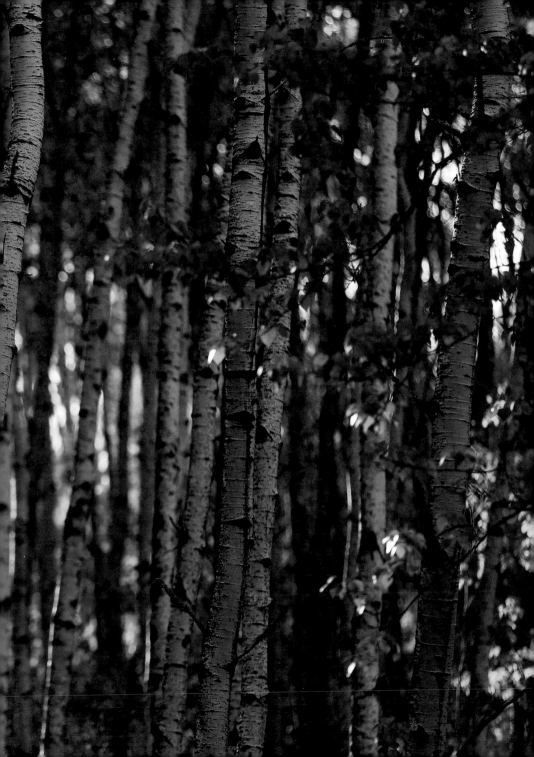

BELOW :~ Cotton grass finds a good place to grow in the boggy area of a field. These hardy perennials, believed to be medicinal, have been used for candlewicks, pillow stuffing, and wound dressings. (Rideau Lakes)

FACING ABOVE :~ The sun sets on Lake Ontario's shoreline at Mimico, a neighbourhood in Toronto's west end, established in 1905. (Etobicoke)

FACING BELOW :~ Built in 1936 as a carding mill, Hope Sawmill was expanded in 1873 to focus on sawmilling. Restored to working condition, it sits in a picturesque area close to the Hope Mill Conservation Area. (Lang)

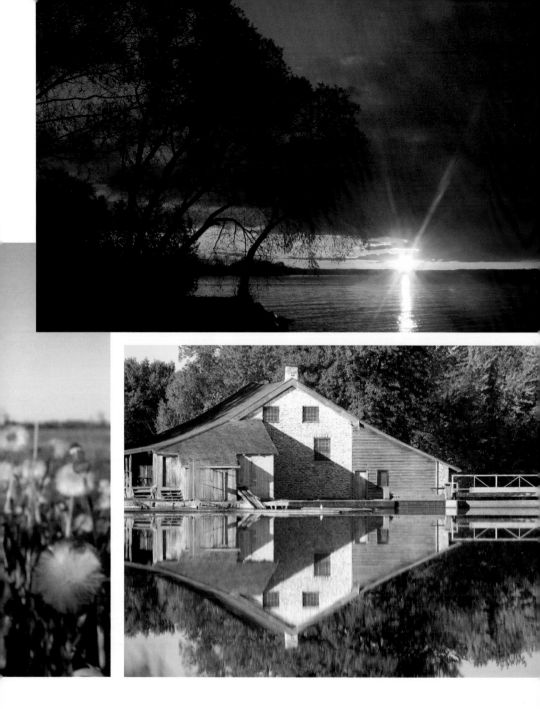

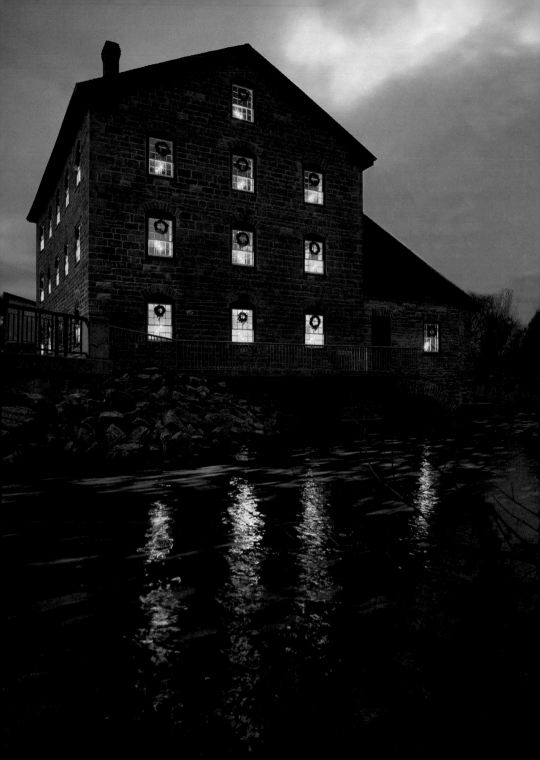

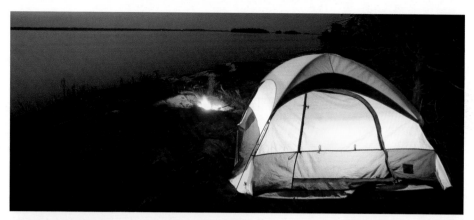

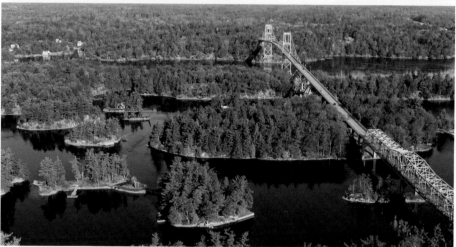

FACING ∾ Lauded for its magnificent restoration, the Old Stone Mill is a wonderful example of a fully automatic gristmill from the Upper Canada era. Built in 1810, it is now in the care of the Delta Mill Society. (Delta)

ABOVE ∾ The epitome of a Canadian getaway, camping under millions of stars is an experience to treasure. (The Thousand Islands)

BELOW ∾ The Thousand Islands bridge system is a series of five bridges connecting northern New York in the United States with southeastern Ontario in Canada. The Canadian span of the Thousand Islands bridge system is 1,015 metres long. (Near Lansdowne)

OVERLEAF ∾ Autumn sunshine seems to set a maple forest canopy on fire in Algonquin Provincial Park. Ten of the roughly 150 species of maple are native to Canada.

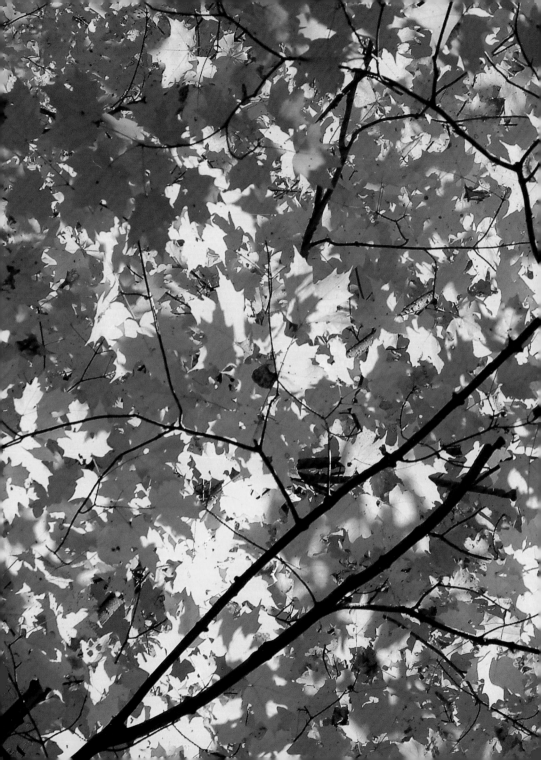

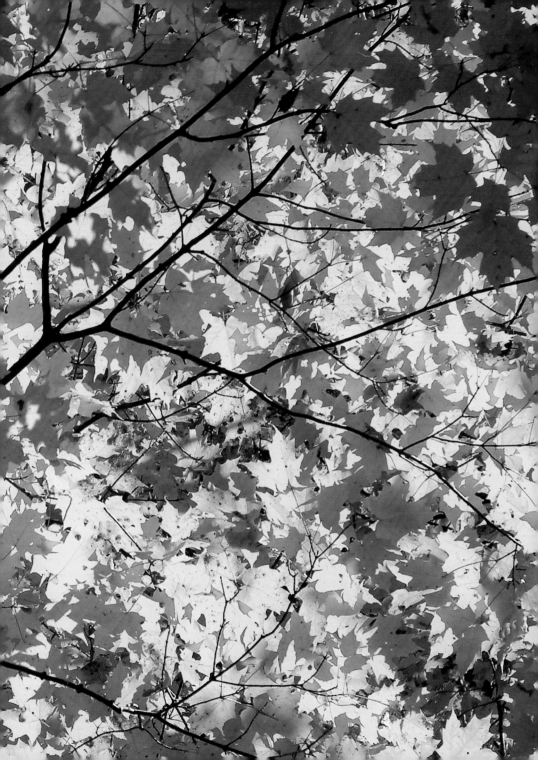

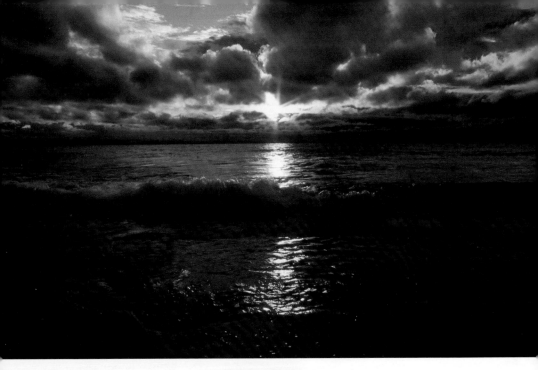

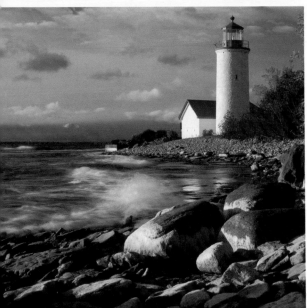

ABOVE :~ From the shore of Nine Mile Point you can look across the length of Lake Ontario. (Simcoe Island)

BELOW :~ Protecting the southwest shore of Simcoe Island (named for John Graves Simcoe), Nine Mile Point Lighthouse has a commanding view of the St. Lawrence River. Built in 1833 and automated in 1978, the light shines from a height of almost 14 metres. (Simcoe Island)

FACING :~ From Ottawa to Kingston, the Rideau and Cataraqui Rivers, along with several lakes, make up the 202 kilometres of the Rideau Canal system, with forty-five locks regulating the route. (Rideau Lakes)

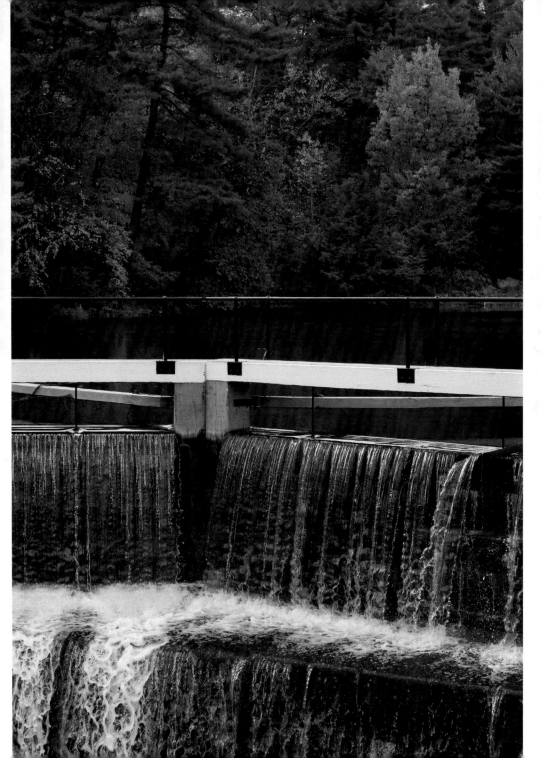

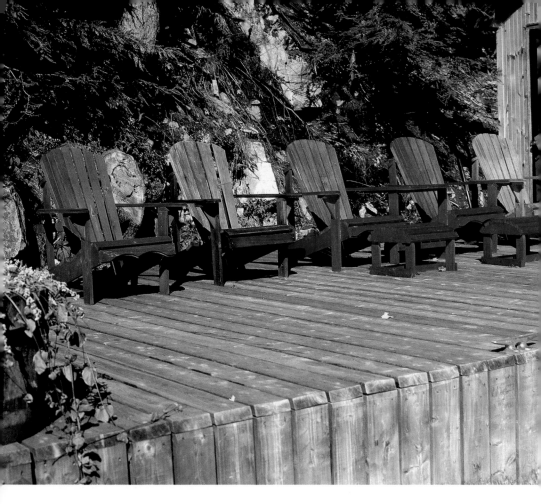

ABOVE ∿ Bold colours on traditional Muskoka chairs encourage visitors to stop and stay a while. (The Thousand Islands)

FACING ABOVE ∿ Discovering the tracks of an early bird is a treat in Sandbanks Provincial Park. (Picton)

FACING BELOW ∿ January chill creates a misty effect where air and water fight for dominance. Best viewed from a comfy armchair beside a fireplace. (The Thousand Islands)

OVERLEAF ∿ Corn is a versatile crop providing a favourite seasonal dish: corn on the cob. Dried stalks after the harvest are used for animal feed, marshmallows, toothpaste, fireworks, and even biofuel. (Near Orillia)

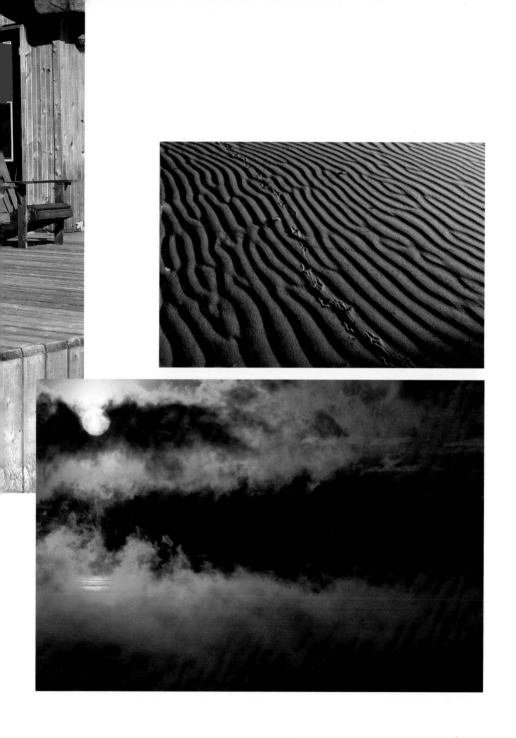

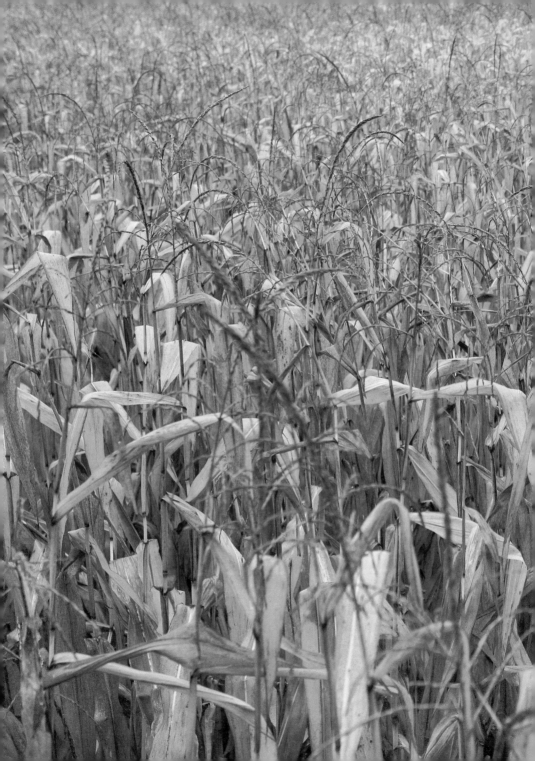

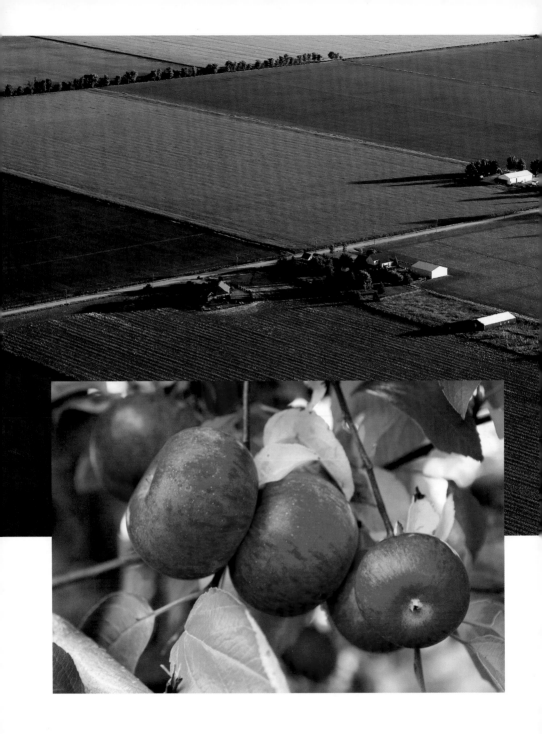

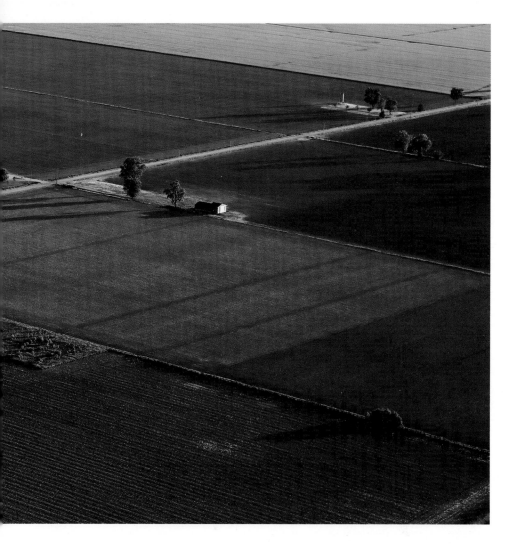

ABOVE ∾ Settled in the late 1700s, the townships around Lake Erie have a colourful history—taking in fugitive slaves from the USA in the 1800s, surviving fires, political strife, a tollgate rebellion, and a railway explosion. The region is now an important agricultural district. (Near Essex)

FACING BELOW ∾ Twenty different varieties of apples are grown in Ontario, mainly along the southern stretches. The crisp, nutritious fruit provides a high-fibre, low-fat snack. It is amazingly versatile and delicious raw or baked, sauced, simmered, grilled, or frozen. Apples add special flavour to pies, cobblers, crumbles, salads, ice cream, and dumplings. (Chudleigh's Farm, Milton)

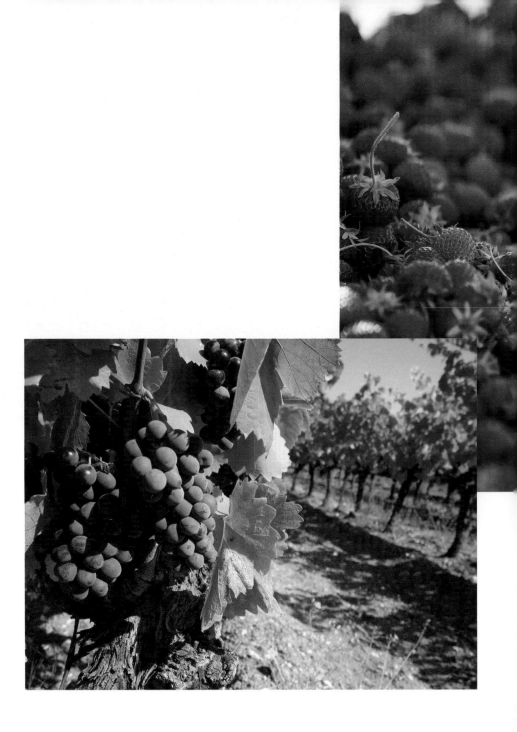

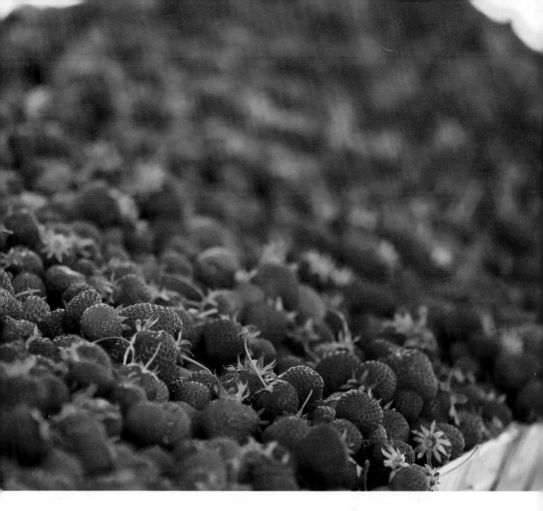

ABOVE :~ Best cultivated in a cool, moist climate, strawberries find southern Ontario a perfect growing area. A member of the rose family, they are at their best in June or July, when you can buy baskets of them from growers or pick your own. (Near Waterford)

FACING :~ Ontario is home to more than two hundred different wineries in Niagara, Prince Edward County, the Lake Erie north shore, and other emerging regions. According to Ontario Minister of Agriculture, Food and Rural Affairs, Jeff Leal, "Ontario has grown to become Canada's largest wine region, providing more than 7,000 direct jobs." (Niagara-on-the-Lake)

OVERLEAF :~ Sunflowers in the budding stage turn their faces to the sun. Ontario sunflowers are generally used for birdseed and confection. (Hamilton)

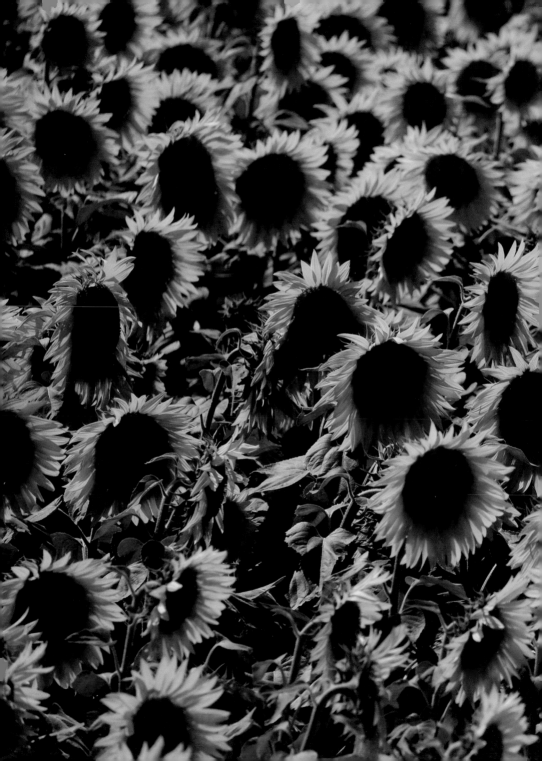

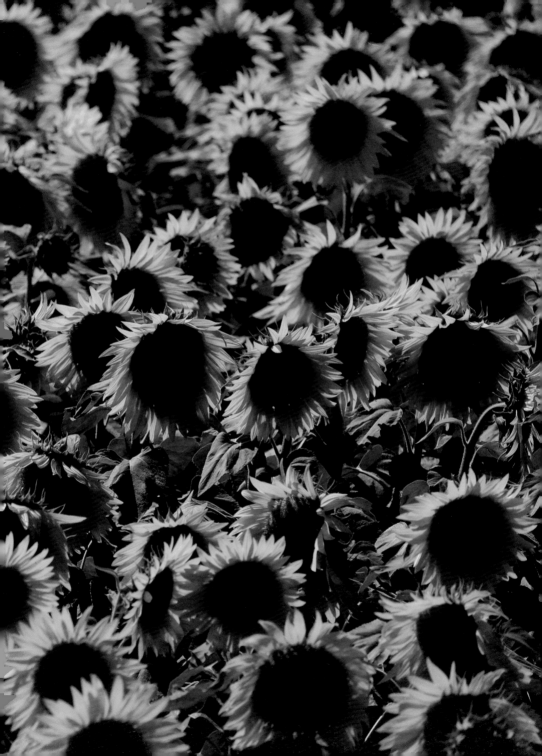

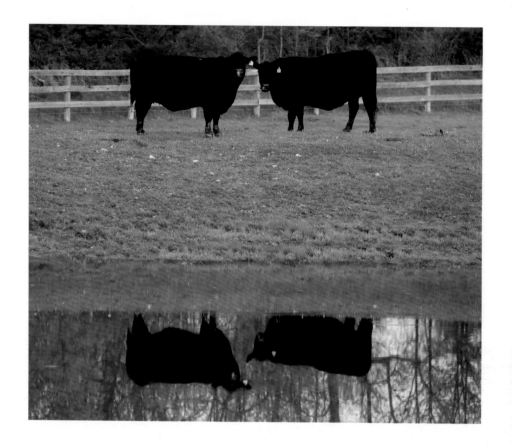

ABOVE ∿ Beautiful black Angus cattle pose for the camera. This docile and hardy English breed produces top-quality beef. (Near Ariss)

ABOVE FACING ∿ A familiar sight on farms around the province, clusters of tall, sturdy silos provide storage for livestock feed. (Caledon)

BELOW FACING, ∿ Fiddleheads prefer growing in damp ground by rivers or streams. A tasty delicacy, they can be boiled or steamed, as well as seasoned with butter, garlic, and spices. (Ottawa Valley)

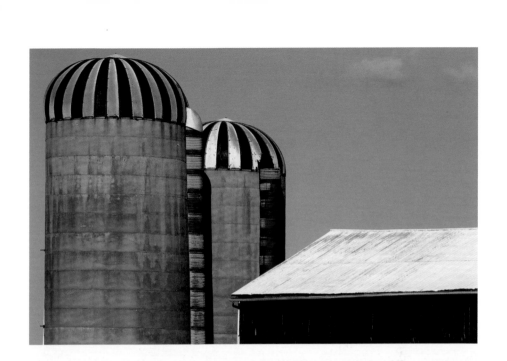

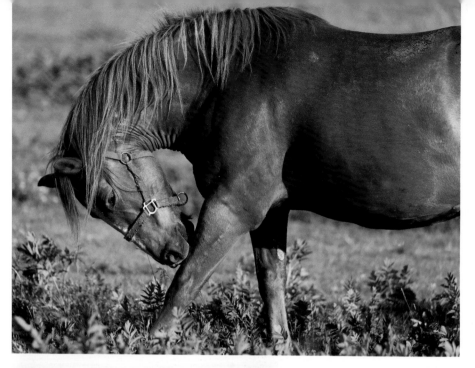

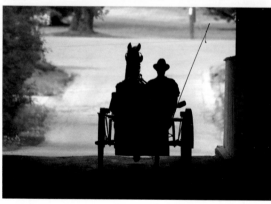

ABOVE ∿ With their gentle ways and loyal souls, horses are popular pets. Some industries are returning to horsepower in an effort to reduce damage to the environment caused by heavy equipment. (Near Glenora)

BELOW ∿ A Mennonite farmer exits West Montrose Covered Bridge in his buggy. Since the rushing water below could frighten horses, the bridge's walls help buffer the noise. (West Montrose)

FACING ∿ The unique architecture of the Caledonia Mill boasts three and a half storeys plus a basement and a decorative cupola. It began milling wheat into flour in 1857 and closed in 1966, becoming the last mill powered by water along the Grand River. (Caledonia)

OVERLEAF ∿ A weathered post fence outlines a farmer's field. (Southern Ontario)

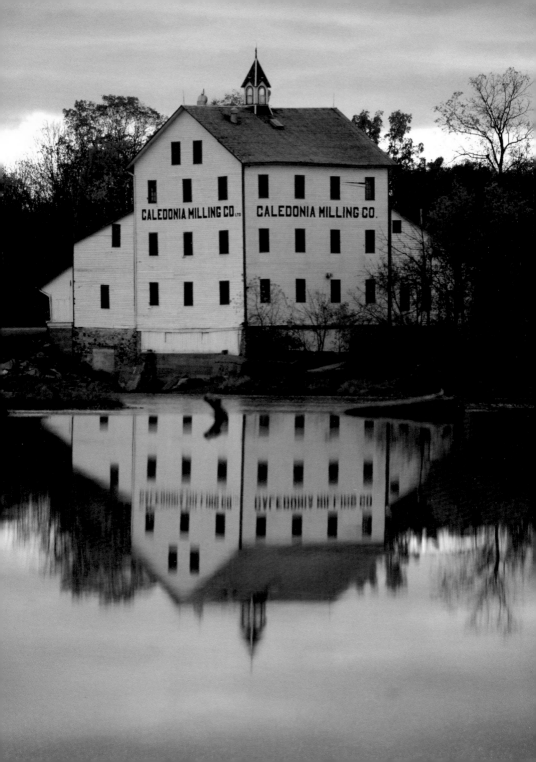

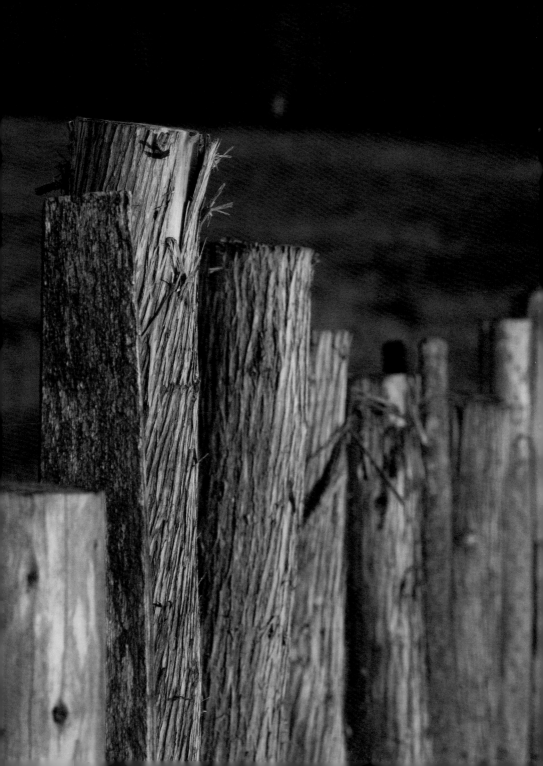

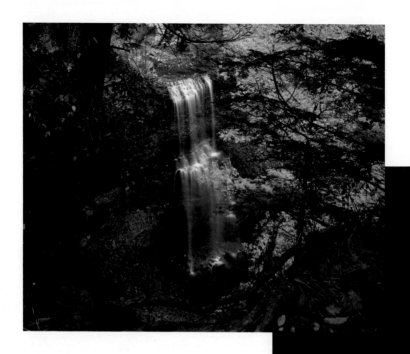

ABOVE :~ Close to urban development but surrounded by a woodlot in the Vinemount Moraine, Felkers Falls cascades over a 20-metre precipice to fascinating rock layers at its base. (Hamilton)

BELOW :~ The Rideau River drops to meet the Ottawa River from two high cliffs separated by Green Island. Important during the mid-1800s for its hydropower, this spot was redeveloped into Rideau Falls Park after the Second World War. (Ottawa)

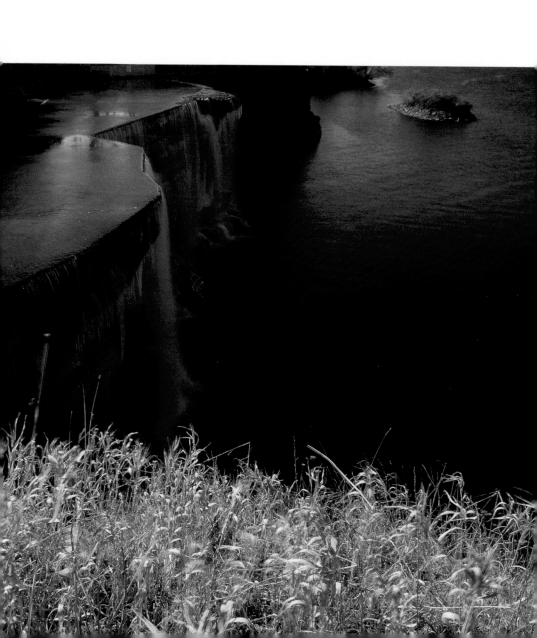

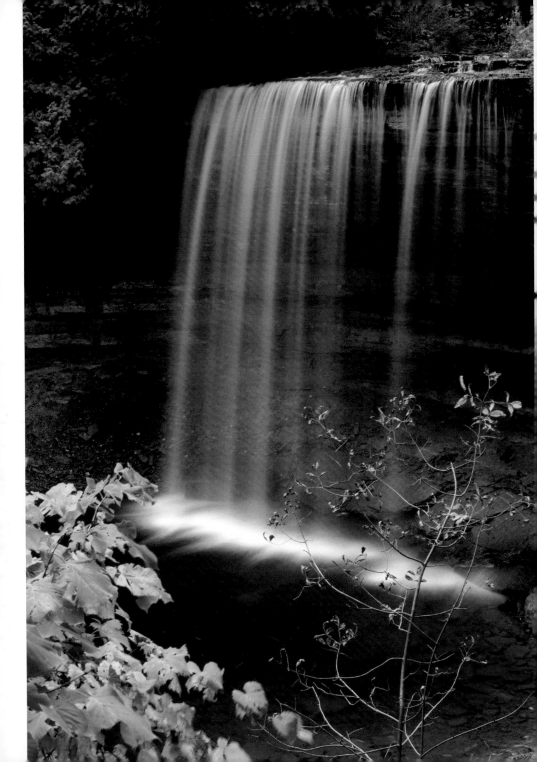

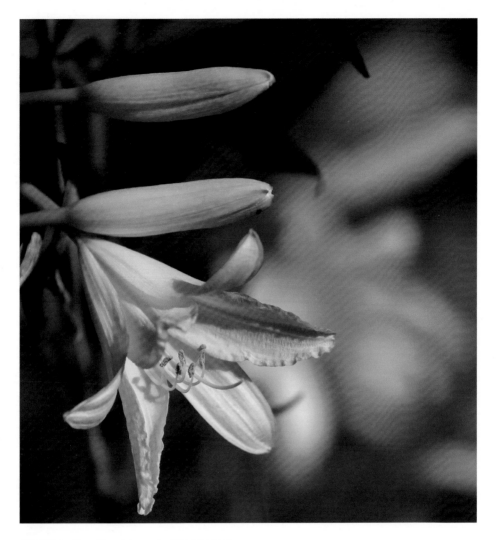

ABOVE ∾ Day lilies bloom in Cheltenham.

FACING ∾ Bridal Veil Falls plunges prettily for about 12 metres over limestone. It is a restful spot for cooling off in the pool or under the "veil" after exploring nearby trails, the town on Mudge Bay, and the pulp mill. (Kagawong)

OVERLEAF ∾ Rolling mounds of Queenston shale are a hallmark of the Cheltenham Badlands. This rare site, cared for by the Bruce Trail Association, is regulated by law to preserve its integrity. (Cheltenham)

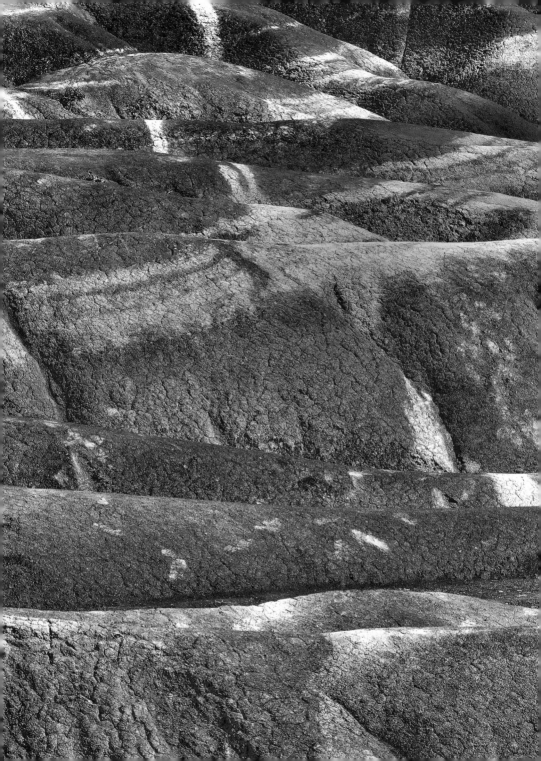

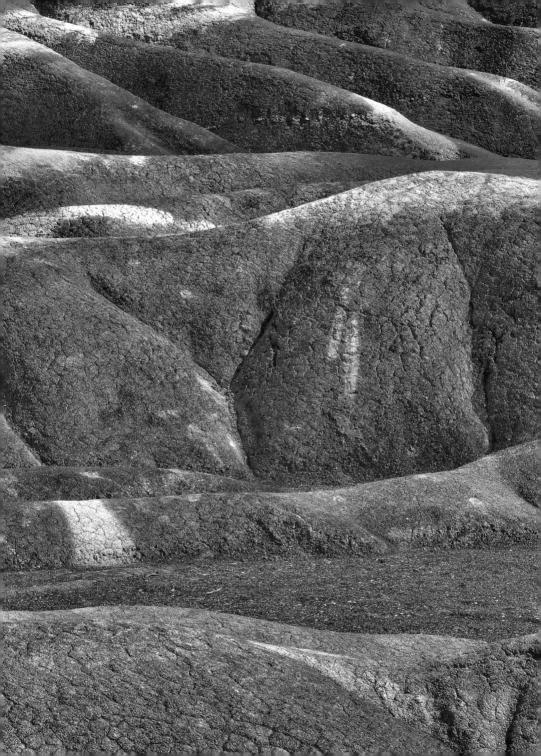

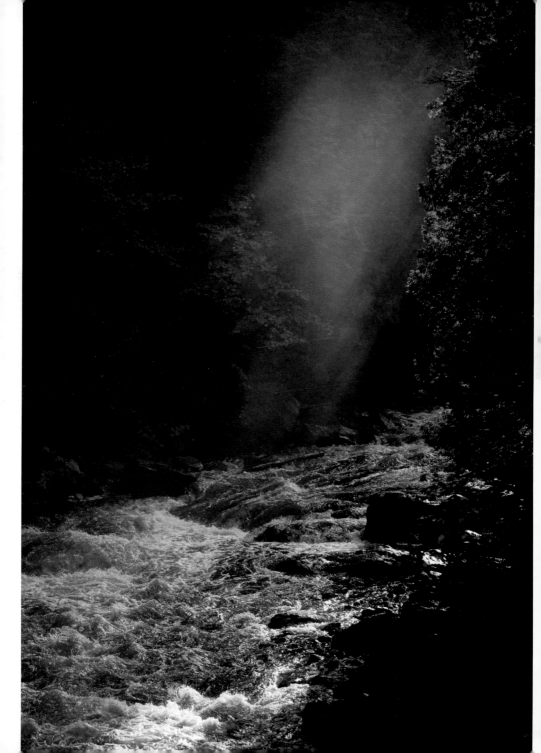

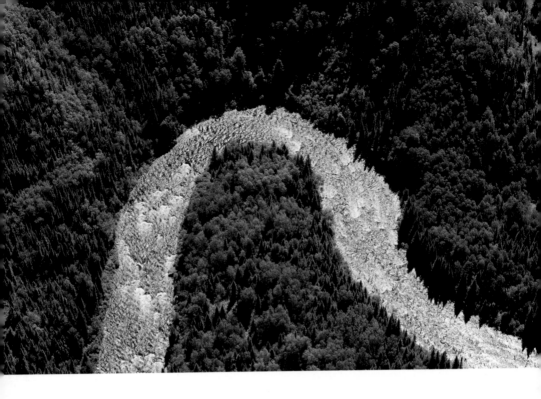

ABOVE :~ A winding river pushes its way through the verdant boreal forest, which comprises two-thirds of the province's 50 million hectares of woodland. (Northern Ontario)

FACING :~ Lucent rays break through the trees where the Amable du Fond River tumbles into Smith Lake from Eau Claire Gorge Falls. (Calvin)

OVERLEAF :~ Sea stacks that resemble flowerpots create the 2-square-kilometre area of Flowerpot Island. Accessible only by boat, it is part of Fathom Five National Marine Park. (Tobermory)

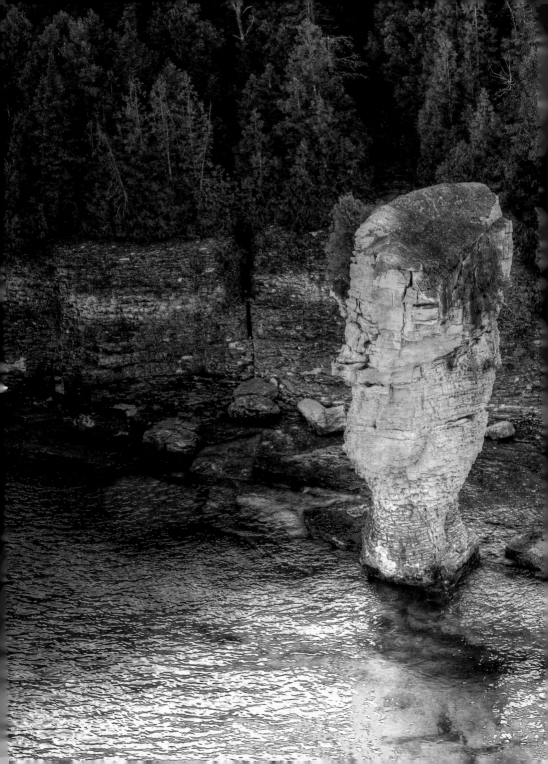

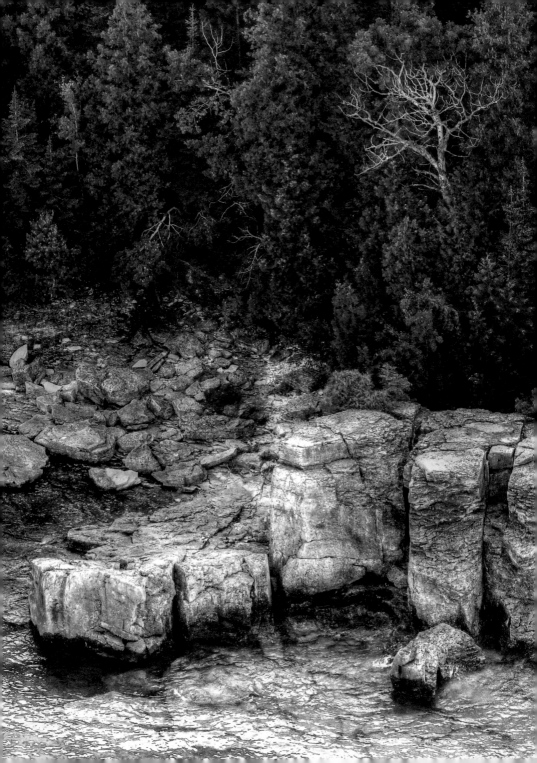

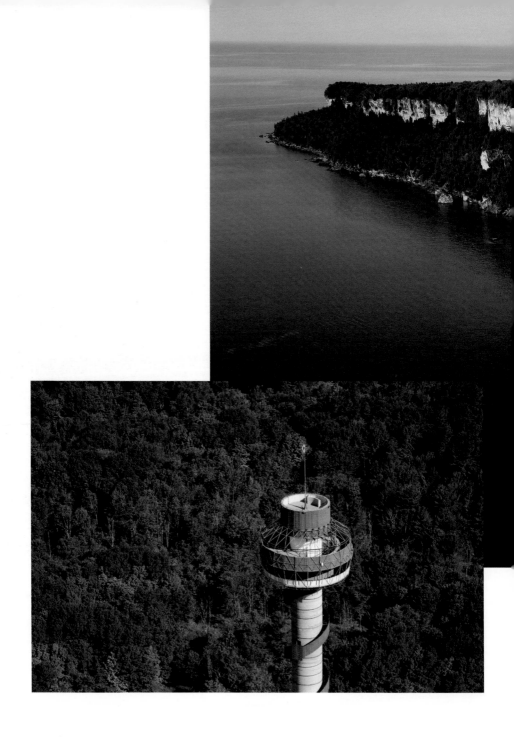

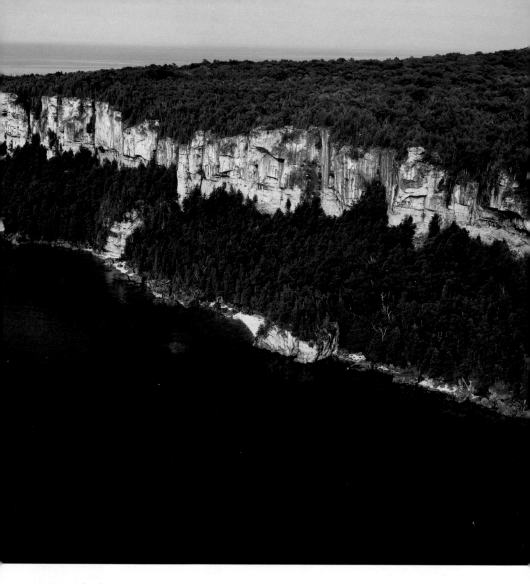

ABOVE ↝ Ancient white cedars cling to soaring cliffs on the Niagara Escarpment on Georgian Bay. Incredible vistas reward hikers visiting Lion's Head Provincial Park. Nearby, the Bruce Trail passes the Tobermory trailhead, then runs 885 kilometres to Queenston. (Lion's Head)

FACING ↝ A quick elevator ride to the observation decks on the Thousand Islands Tower sends visitors up 130 metres to observe the panorama from on high. (Lansdowne)

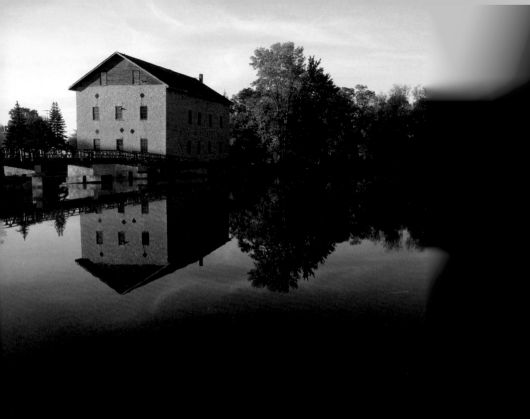

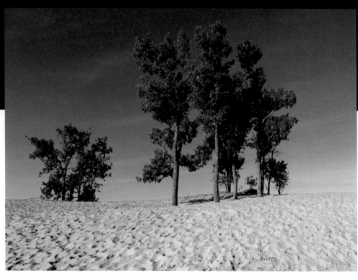

FACING ABOVE :∼ Now part of Lang Pioneer Village, Lang Mill produced up to 8,000 barrels of flour annually during its heyday in the mid-1800s. Powered by the Indian River, its working turbine is set inside the mill. (Keene)

FACING BELOW :∼ A small stand of trees defines the horizon along the dunes in Sandbanks Provincial Park. The trees are part of a 1921 reforestation project spearheaded by the provincial government to stabilize the dunes. (Picton)

BELOW :∼ Serene scenic layers take shape in the early morning light. (Near Kingston)

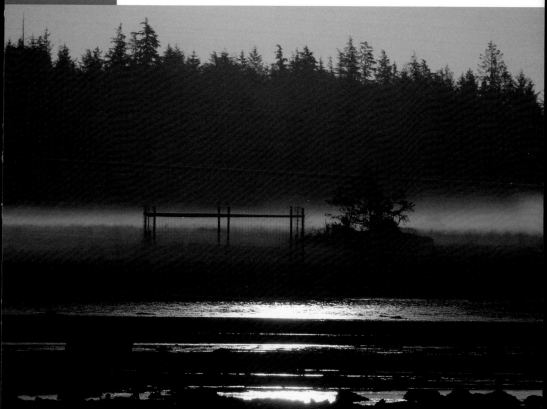

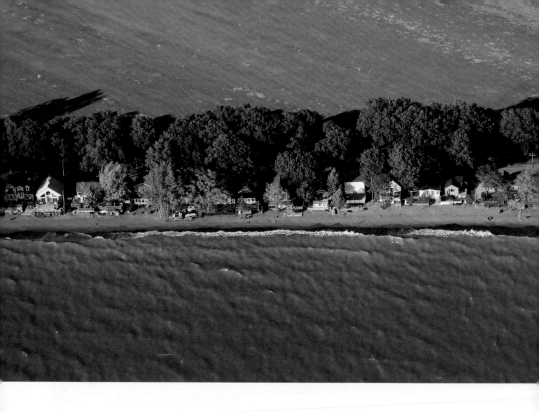

ABOVE ∿ On the same latitude as northern California, the north shore of Lake Erie enjoys a long growing season and some of the nation's most fertile soil. (Leamington)

FACING ∿ Slipping through granite cliffs, the Mississagi River forms the isolated Aubrey Falls. At 53 metres high, it is the feature of the Aubrey Falls Provincial Park. (Massey)

OVERLEAF ∿ Built in 1881, the West Montrose Covered Bridge is also known as "the Kissing Bridge." (West Montrose)

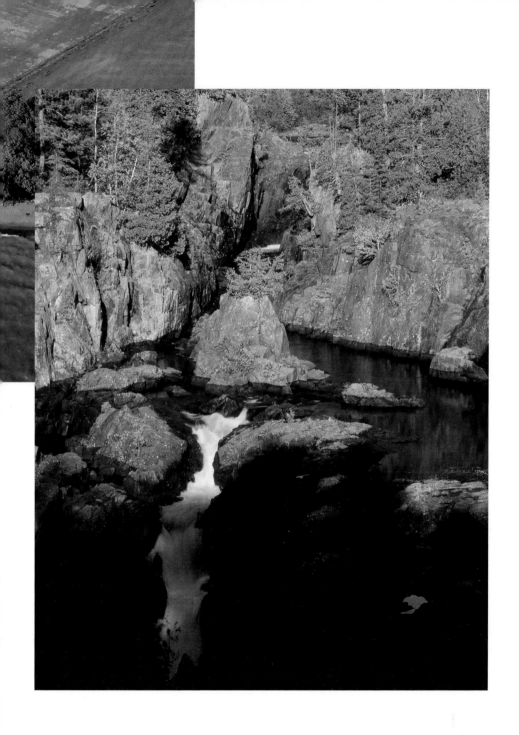

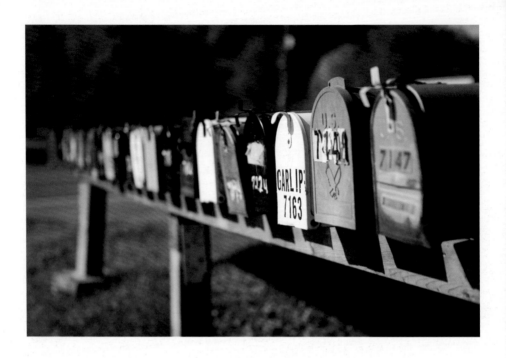

ABOVE ∿ A familiar rural sight, a mailbox lineup faces the roadside. The federal government has handled Canada's postal service since 1868. (Gananoque)

ABOVE FACING ∿ Abandoned decades ago, Canadian Forces Base (CFB) Picton has the feel of a ghost town. The authentic set was used by CBC for its made-for-TV movie *Dieppe*. (Picton)

BELOW FACING ∿ CFB Picton was built as a wartime training installation. Though now used for cadet programs and some private enterprises, it was a dynamic hub from 1938 to 1969. (Picton)

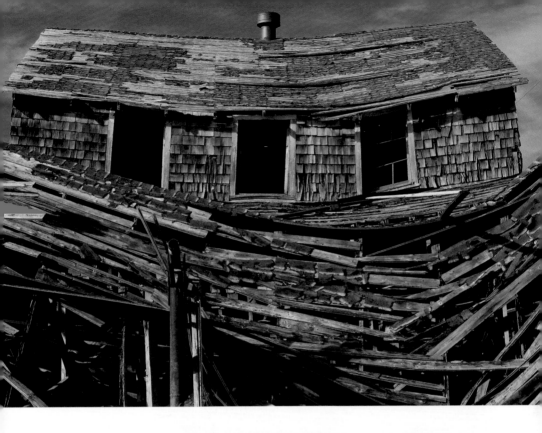

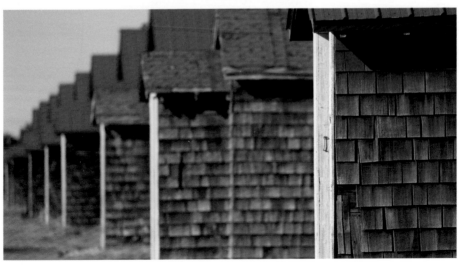

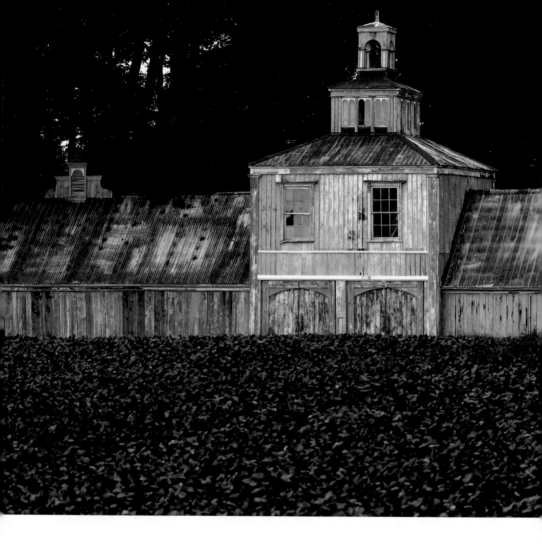

ABOVE ∿ Like sentinels of past lives, ghostly buildings with stories to tell dot the landscape. (Near Owen Sound)

FACING ∿ Fashioned in the High Victorian Gothic Revival style, Belleville City Hall features a 44-metre clock tower. The building was completed in 1873 during an economic depression as a symbol of civic pride and confidence in the future. (Belleville)

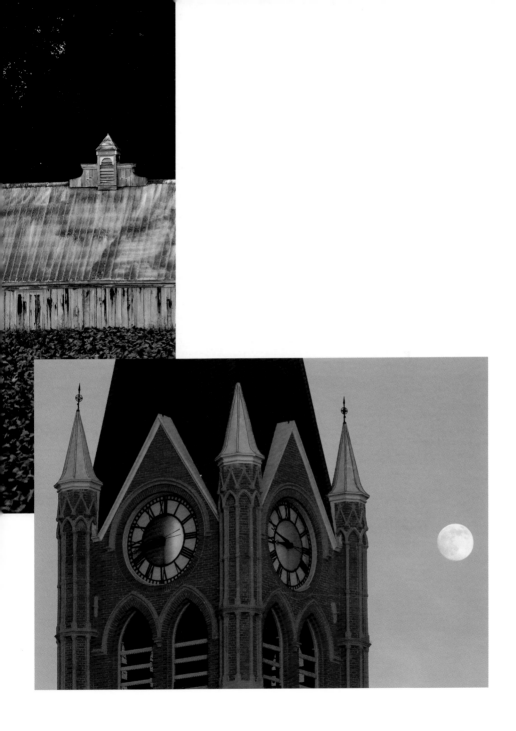

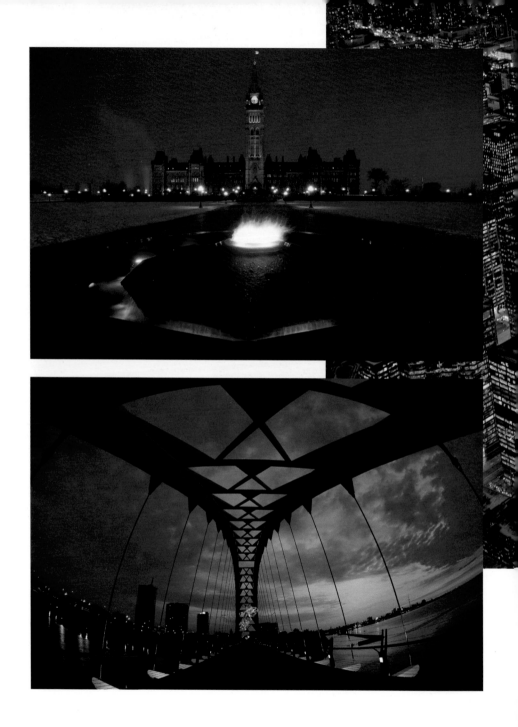

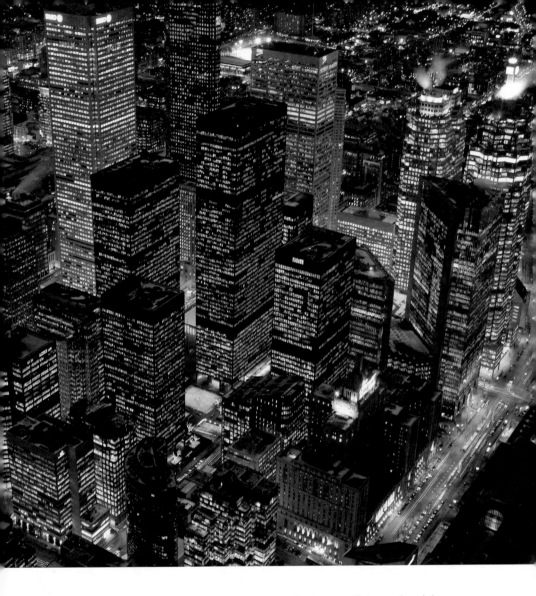

ABOVE ⁖ Viewed from the CN Tower, downtown skyscrapers light up the night. (Toronto)

ABOVE FACING ⁖ The Centennial Flame commemorating Canada's Confederation burns in front of the Peace Tower on Parliament Hill. (Ottawa)

BELOW FACING ⁖ Humber Bay Arch Bridge. (Etobicoke)

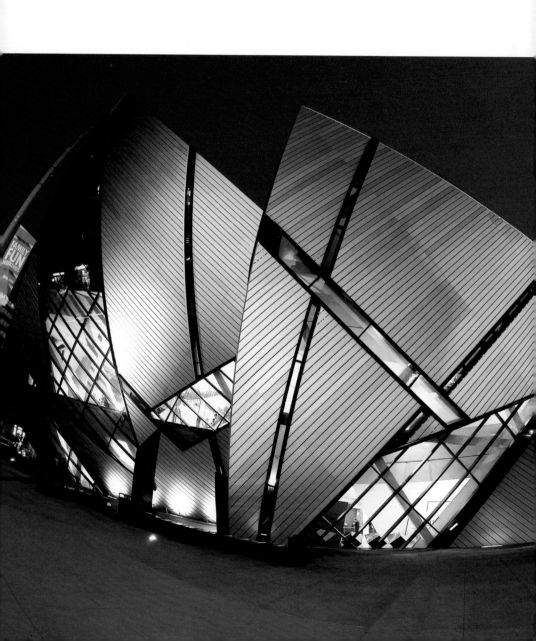

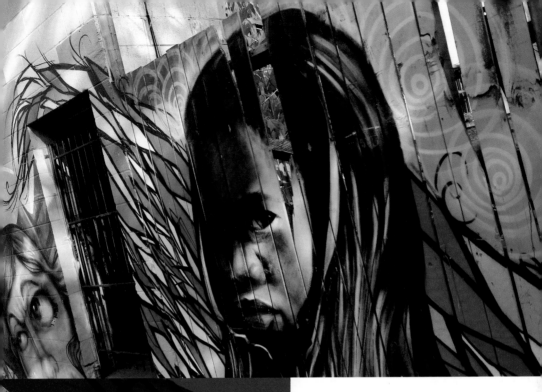

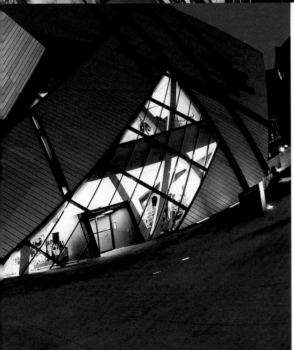

ABOVE :~ Graffitied wall and fence. (Queen Street, Toronto)

FACING :~ With a luminous evening glow, the Michael Lee-Chin Crystal marks the entrance to the Royal Ontario Museum (ROM), one of Canada's largest museums. (Toronto)

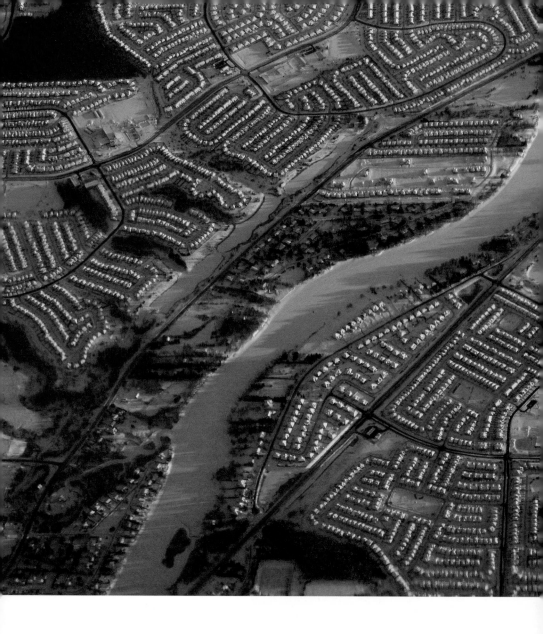

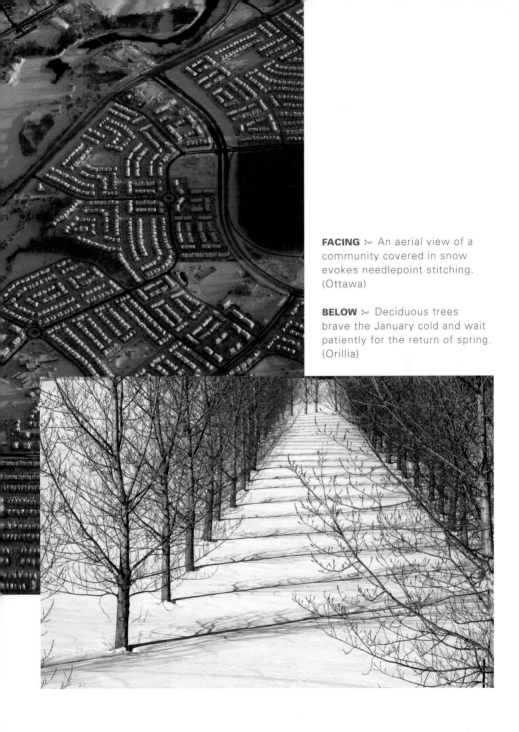

FACING ∿ An aerial view of a community covered in snow evokes needlepoint stitching. (Ottawa)

BELOW ∿ Deciduous trees brave the January cold and wait patiently for the return of spring. (Orillia)

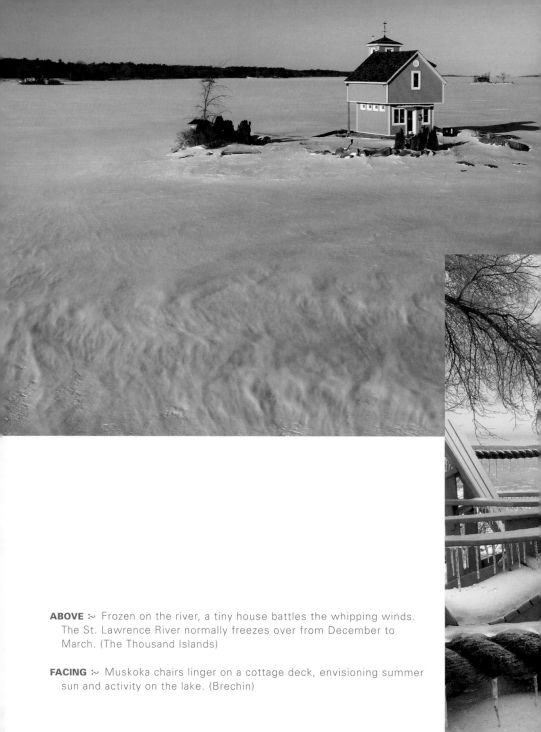

ABOVE :~ Frozen on the river, a tiny house battles the whipping winds. The St. Lawrence River normally freezes over from December to March. (The Thousand Islands)

FACING :~ Muskoka chairs linger on a cottage deck, envisioning summer sun and activity on the lake. (Brechin)

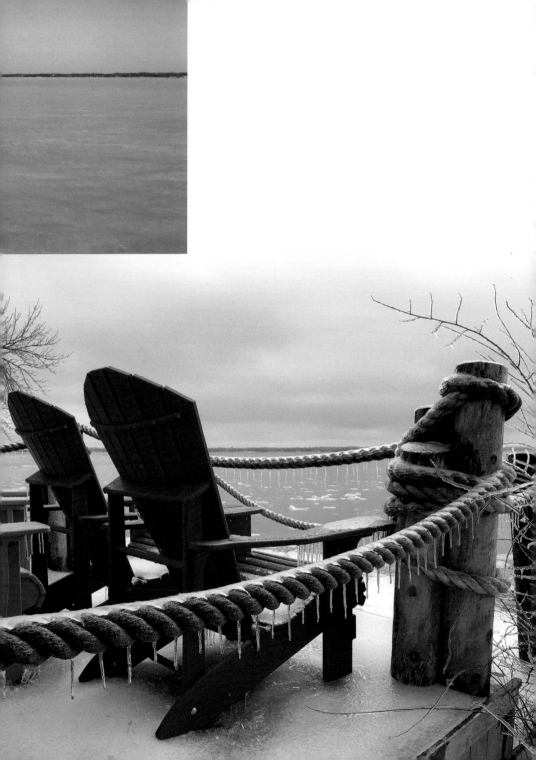

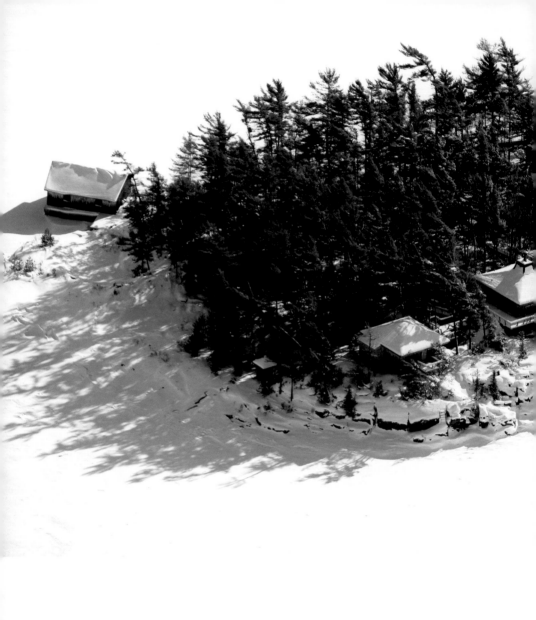

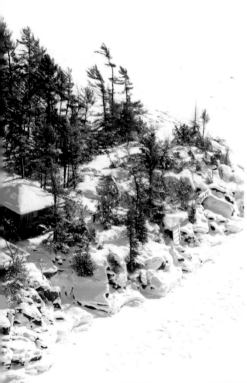

FACING :~ A very different vista in the winter, the profile of Sugar Island is typical of many of the 30,000 Islands. (Georgian Bay)

BELOW :~ Shards of ice buckle skyward against waves that continue pushing the frozen lake against the shore. (Near Atherley)

OVERLEAF :~ Winter ice storms never fail to elicit a sense of awe as they turn the landscape surreal. (Near Beaverton)

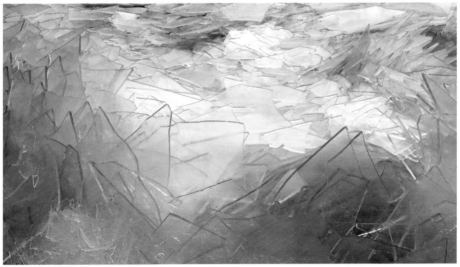

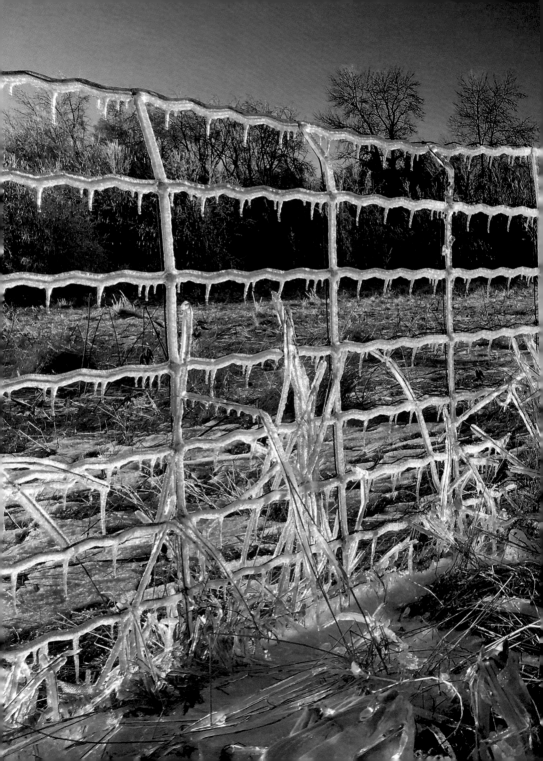

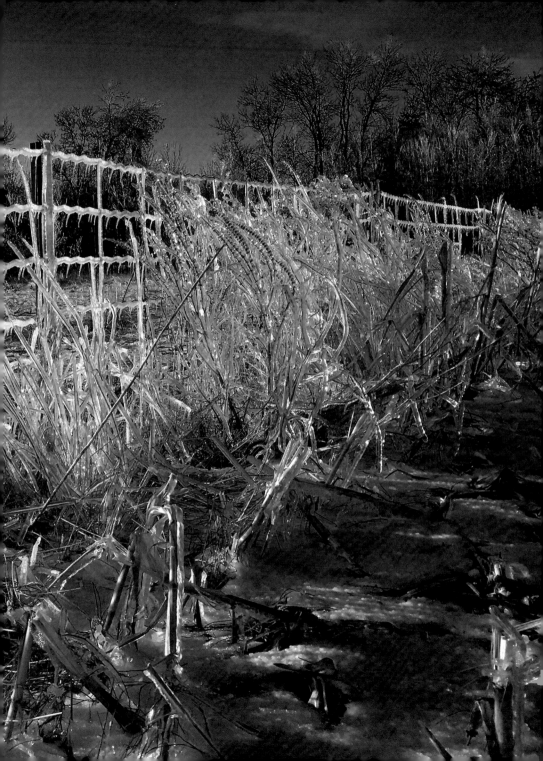

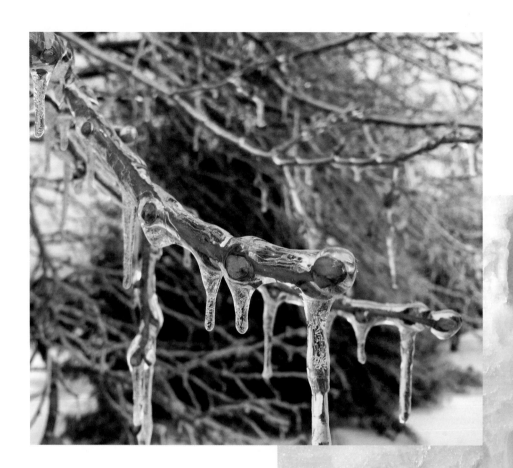

FACING :~ Early buds, assaulted by a late freeze, generally survive brief drops in temperature as spring fights its way in. (Near Brechin)

BELOW :~ Snow and ice sculpt a unique temporary scene. (Ragged Falls, Algonquin Park)

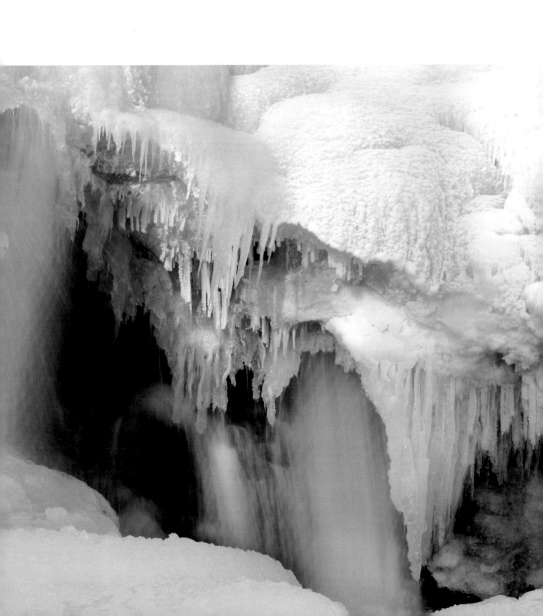

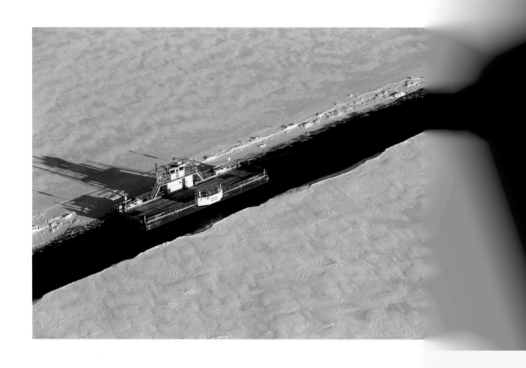

ABOVE :~ From the mainland to Howe Island, the *Frontenc–Howe Islander* ferries passengers and their cars year round, twenty-four hours a day. The vessel's operating history dates back to 1898. It is now owned by the Ontario Ministry of Transportation and operated by the County of Frontenac. (Kingston)

FACING :~ For more than 202 kilometres, the Rideau Canal links the Ottawa River to Lake Ontario at Kingston. The popular skating portion in Ottawa is flooded at night by city workers who drill holes in the ice that pump water upwards to smooth the surface. (Ottawa)

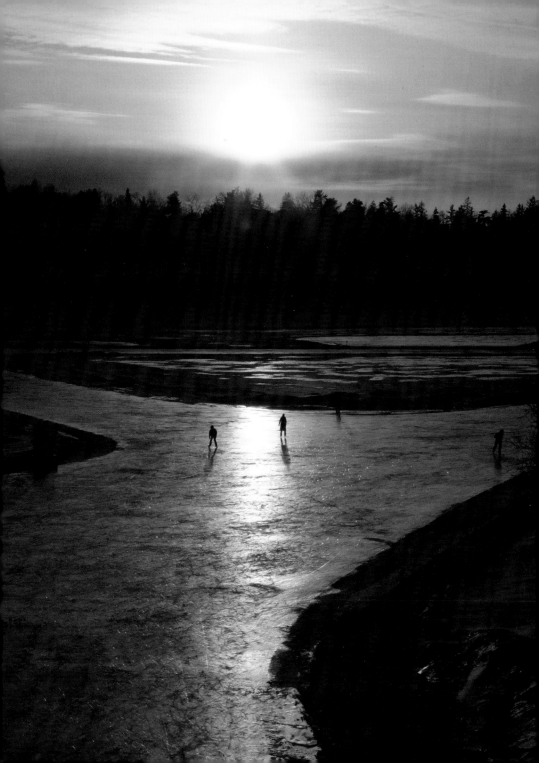

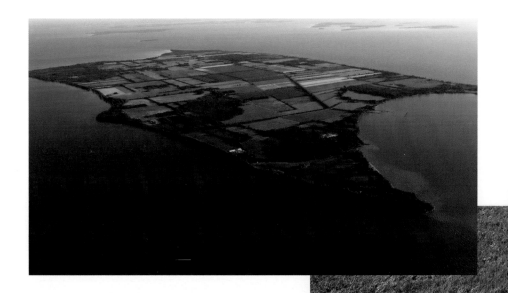

ABOVE ∿ Middle Island is Canada's southernmost point, roughly parallel to Barcelona, Spain, and Rome, Italy. (Point Pelee)

FACING ∿ Thick marshland outlines the rich natural habitat in Halstead's Bay. River marshes are exceptional places for spotting wildlife such as marsh birds, beaver, and muskrat. (Near Ivy Lea)

OVERLEAF ∿ An aerial view displays the underwater landscape near Whiskey Harbour, a thrilling backyard for those living in the area. (Northern Bruce Peninsula)

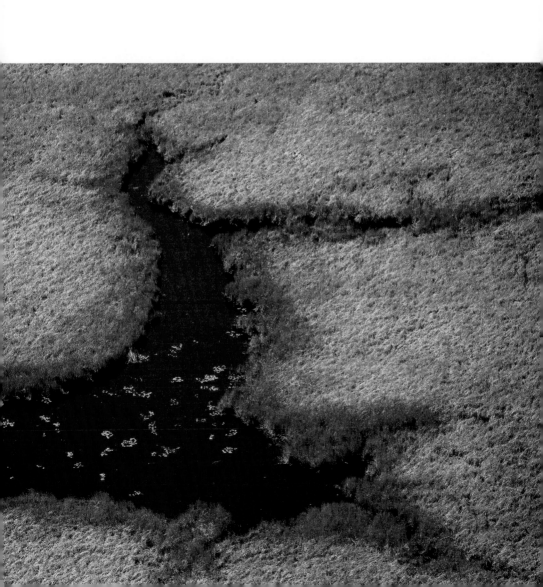

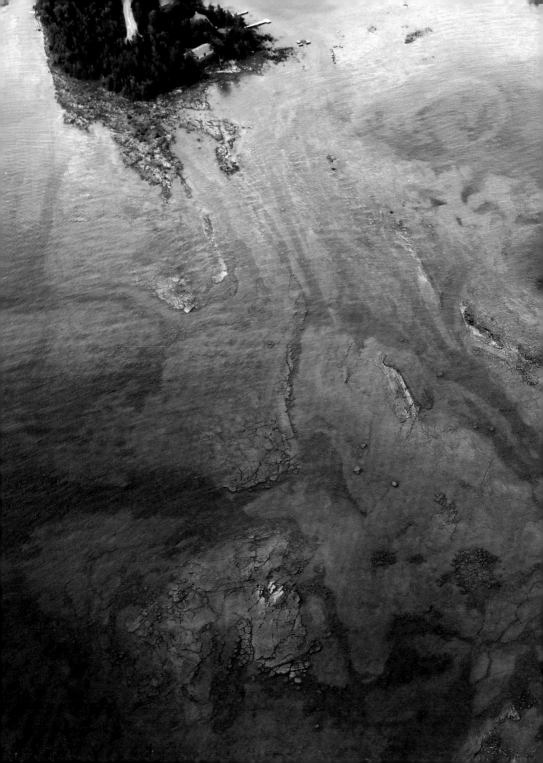

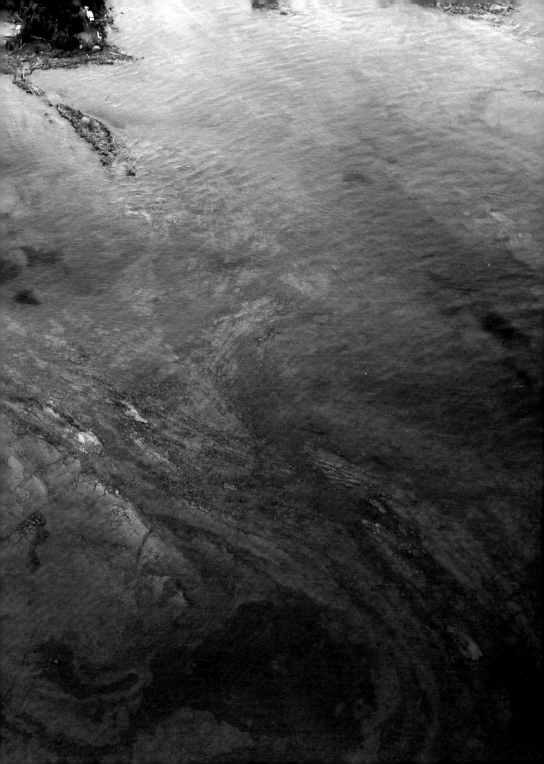

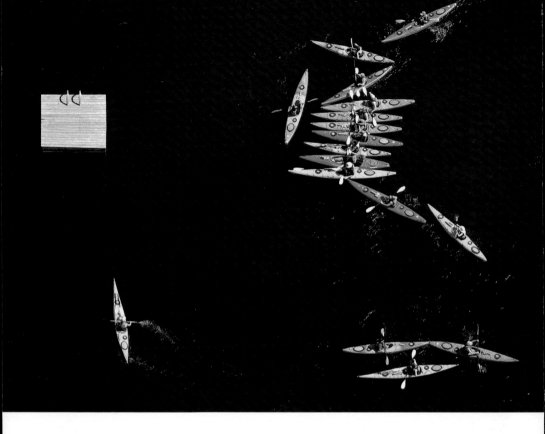

ABOVE :~ Paddlers flock to a deepwater swimming dock off the sandy shores of Joel Stone Park. (Gananoque)

ABOVE FACING :~ Tobermory offers outdoor enthusiasts countless entertaining activities, from cliffs and caves to crystal-clear water. Fathom Five National Marine Park has preserved more than twenty historic shipwrecks that thrill divers and snorkellers. (Tobermory)

BELOW FACING :~ Marking the border of Ontario and New York State, the Niagara River surges over the American Falls and the Canadian Horseshoe Falls (shown here), both dropping roughly 57 metres. The combination of height and volume makes Niagara Falls one of the world's most popular tourist attractions. (Niagara Falls)

OVERLEAF :~ A secluded shoreline shows off an artistic natural design. (Kincardine)

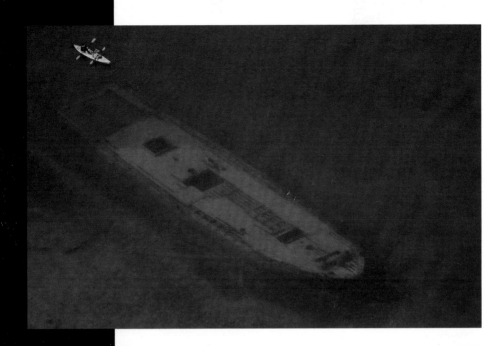

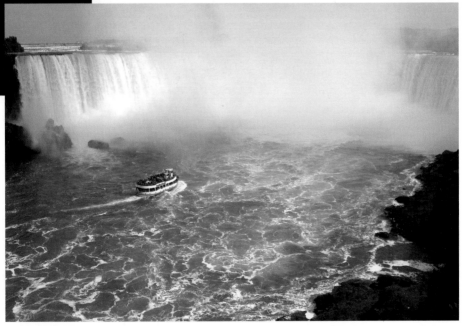

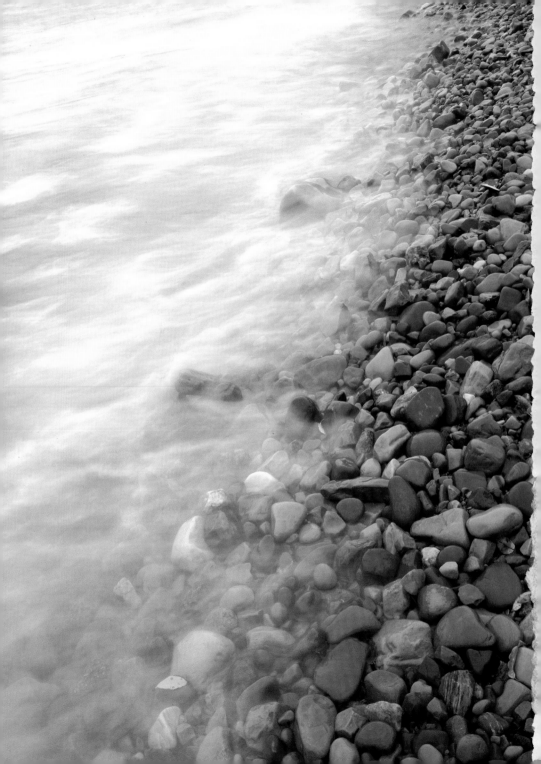